PERCEPTION

KC Adams

Perception: A Photo Series

Foreword by Katherena Vermette

Critical Essay by Cathy Mattes

HIGHWATER
PRESS

Library and Archives Canada Cataloguing in Publication

Adams, K. C., 1971-, author, photographer
 Perception : a photo series / KC Adams ; foreword
by Katherena Vermette.

ISBN 978-1-55379-786-9 (hardcover)

 1. Photography, Artistic. 2. Adams, K. C., 1971-.
I. Vermette, Katherena, 1977-, writer of foreword II. Title.

TR647.A325 2019 779.092 C2018-906345-9

Canada Council **Conseil des Arts**
for the Arts **du Canada**

We acknowledge the support of the Canada Council for
the Arts, which last year invested $153 million to bring
the arts to Canadians throughout the country / Nous
remercions le Conseil des arts du Canada de son soutien.
L'an dernier, le Conseil a investi 153 millions de dollars
pour mettre de l'art dans la vie des Canadiennes et des
Canadiens de tout le pays.

HighWater Press gratefully acknowledges the
financial support of the Province of Manitoba through
the Department of Sport, Culture and Heritage, and
the Manitoba Book Publishing Tax Credit, and the
Government of Canada through the Canada Book
Fund (CBF), for our publishing activities.

THE DEBWE SERIES

Exceptional Indigenous Writing from Across Canada

www.highwaterpress.com
Winnipeg, Manitoba
Treaty 1 Territory and homeland of the Métis Nation

Contents

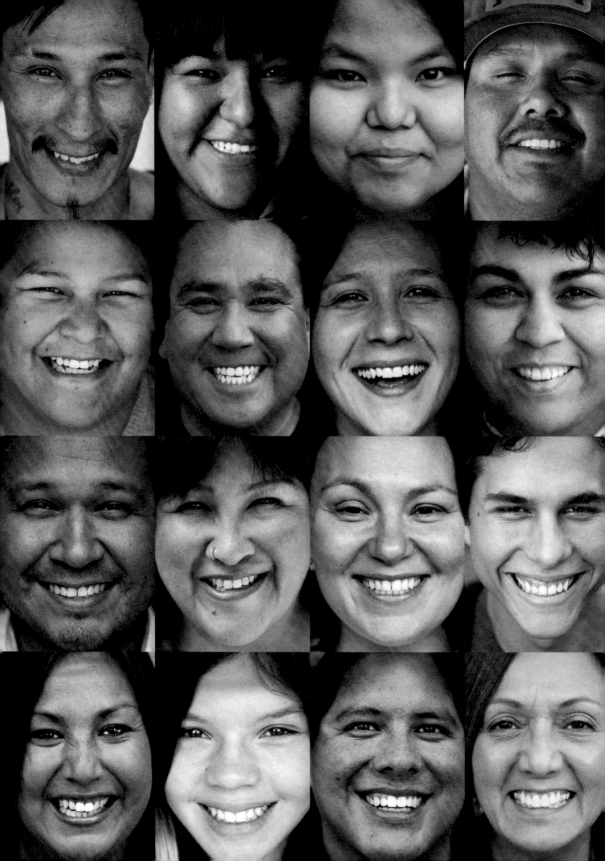

Before Words

I first heard of *Perception* in the summer of 2014 when someone
had forwarded KC's request for models for a new project. As
soon as I saw her beautiful face, first in a grimace, then in pure
happiness, I knew I wanted to be a part, and messaged her before
I could chicken out. I had known of KC's work for years and greatly
admired everything she did. She immediately invited me to her
home, to have tea and take some photos, and within a week, I
was sitting in her big back yard having tea. She had a big garden,
swing, firepit, a kiln in her garage – an artist's paradise – and I
liked her immediately. We had known of each other and moved in
almost the same circles for years, but I don't think we had ever met
before then. We hit it off right away and talked for a long time. By
the time she went to take my picture, I had nearly forgotten why
we were there.

The setup was as unpretentious as the artist. She stood me
in the light she wanted, and then said she was taking the first
shot. I forget the exact words she used as she directed me, but
it was something about remembering a time I was made to feel
worthless, less than, either in my personal life or in public, a time
when I felt like I didn't belong or was unwanted. I don't remember
what she said, but I will never forget what it made me think of –

7

walking down the street in Winnipeg, getting honked and leered at by men in passing cars. That feeling of being looked at and not being seen. I nearly cried looking into KC's camera. And was awestruck I could go so deep so fast just from a few simple words.

For the next one, and I remember this completely, she told me to remember the first time I kissed my husband, and I laughed out loud. Okay, she didn't say "kiss." Man, I laughed. It wasn't just the memory, but also the relief of getting out of the previous memory. That's what you see in my pictures – sadness, smallness, and wanting to retreat, and then joy, love, and pure relief. Both are true, and both are only parts of the greater whole. That's what you see in all the photos of *Perception*, and that's the beauty of the project – it's about looking again, looking deeper, and to me, it's also about kindness.

A friend of mine said something brilliant recently – she said kindness is a privilege. Many of us are too often not the recipients of kindness – people are kind to those they relate to, those they are not afraid of. I am talking about the run-of-the-mill, stranger kind of kindness, – the hold-the-elevator-door and smile-on-the-street kind of kindness. It's an overlooked fact because there are so many bigger fish to fry, so to speak, but it's true. Too often others look too quickly and not deep enough. Too often we are not related to, or are found wanting, or worst of all, not even seen as human. But we are. We all are, and we are worthy, as all beings are, of a moment, of consideration, and of kindness. So please, consider these faces in *Perception* and let the project teach you what all great art teaches us: to look, and then look again.

In the Beginning

I stood before my father and cried. I was getting ready to say goodbye after visiting my parents for the weekend, and I suddenly became emotional. Prior to this moment, my career as an artist had been good. Over the period of seventeen years, I had had many solo and group exhibitions, residencies, publications, public art commissions, and so forth. However, I was getting constant requests to show work that I had created years before. I felt stuck, uninspired, and lost. The moment I stood before my father crying, I was facing the reality that I might not have anything left inside of me, that I was washed up as an artist.

Two weeks later, on August 11, 2014, I was on Facebook when a story hit my newsfeed. It was about a Winnipeg mayoral candidate's wife (a prominent woman in Winnipeg) who had written a disparaging post about "drunken native guys" that she posted on Facebook February 11, 2010. It read:

> ...really tired of getting harrassed [sic] by the drunken native guys in the skywalks. we need to get these people educated so they can go make their own damn money instead of hanging out and harrassing [sic] the honest people who are grinding away working hard for their money. We all donate enough money to the government

to keep their sorry assess [*sic*] on welfare, so shut the f**k
up and don't ask me for another handout!

I consider myself a social-practice artist. I highlight social-political
issues using the interaction of the audience. I start with an idea
and then choose a medium that best represents that idea. I
have worked in video, installation, painting, digital photography,
ceramics, printmaking, performance, beading, and kinetic art.
For ten years, I had been thinking about creating an artwork
about stereotypes of the original people of Canada, which was
sparked by a comment made by my sister-in-law. My brother, my
sister, and I had played on an all-Indigenous softball league, and
my sister-in-law would often come to our games. One day she
came up to me and said, "Other than your family, I never really
had contact with Native people. I had no idea how normal they
were." I was taken aback by her comment, but she explained that
her exposure was based on media and seeing drunks on the
street. My artist mind started to work, and I thought, "What if the
majority of the people of Winnipeg thought the same way? How
do I combat people's stereotypes towards Indigenous people
through art?"

Fast forward ten years later. As soon as I read the disparaging
Facebook post, my artistic mind crafted both answer and solution.
I was spurred into action, and on Tuesday, August 12, 2014, I sent
out a request on social media asking for participants who were
Métis, First Nations, or Inuit living in Winnipeg to participate in
a new photo project to combat racism. By late Friday afternoon,
I had five photos ready to edit over the weekend. I wanted to
post the art project first thing Monday morning, since it was the
busiest time for people to log on to social media. I posted the
images on August 18 at 12:01 a.m. because I was so excited to
get this artwork out to the public. Sadly, I found out later that day

that the Winnipeg police had pulled two bodies out of the river the day before. One was Faron Hall, the homeless Anishinaabe man who had saved two people from drowning on two separate occasions. He went into the river to wash himself, got caught up in the strong current, and drowned. The other was Tina Fontaine, a young girl from Sagkeeng First Nation. Beloved by her family, she was found floating in the water, murdered and stuffed in a garbage bag. Both deaths were shocking and disturbing, a hero and a child both meeting their ends in the river. The people of Winnipeg were moved by this little girl's death; they wanted the senseless killing of Indigenous girls to stop. Tina became the poster child for murdered and missing Indigenous women.

My *Perception* photos came out during this dark time, and it sparked conversations about racism. One strength of this work is that it doesn't point fingers at people – it emphasizes the injustice towards the original people of this land. The lack of confrontation allows viewers to react and ponder their own prejudices. At the same time, it gives a voice to the participants and shows the audience that they are staring into the eyes of human beings that deserve respect.

Kim Wheeler was the first person to contact me to participate in the project. We sat down in her kitchen and had a wonderful and insightful conversation that helped shape the protocol for working with the participants thereafter.

Since the project was about racism, I wanted to hear from her about her experiences with it. I already knew that Kim was an educated, intelligent, and talented woman. What she shared was her frustration with people assuming that her education was paid for by the government and that she doesn't pay taxes. It was then I asked her how she would like to be perceived. What

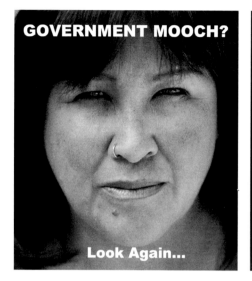

GOVERNMENT MOOCH?

Look Again...

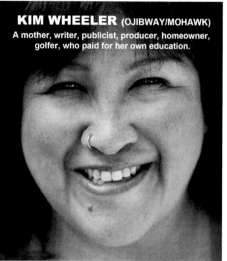

KIM WHEELER (OJIBWAY/MOHAWK)
A mother, writer, publicist, producer, homeowner, golfer, who paid for her own education.

did she want the general public to know about her? Listening to her answers, I realized that I needed to present her the way she defined herself. It was through our conversations that I decided I would use two photos to present this work. The first one would be how people see her — as a "government mooch" — and the second photo would represent how she wanted people to see her.

My technique was simple. I asked her to look into the camera lens and listen to my words. It was important that she hear my words and have an intuitive reaction to them. I asked her to imagine a scenario where she was walking down the street with her daughter, and someone would drive by and call them a bunch of "whores and squaws." The reaction I got from her was classic "mama bear protecting her cub." Her stare was so powerful, I got chills. In the second photo, I asked her to clear her mind. Once she relaxed, I totally threw her off when I asked her to think about when she married her husband, Jordan Wheeler. The shot that I got was of genuine happiness and joy. The experience I had with Kim formed the protocol for the collaboration with each participant.

Once I sent out those first five images on social media, I was flooded with requests from people who wanted to participate in the project. National and local media outlets approached me for interviews. In one of the interviews, I explained how I would like to have the work seen on billboards, bus shelters, and posters. A few months later, Urban Shaman Gallery in Winnipeg reached out to me to make my dream a reality. They had contacted numerous businesses and organizations and raised the monies to launch an ambitious campaign. My art was seen on posters, bus shelters, and billboards all around Winnipeg from March to June 2015. The campaign was so successful, I was invited to Lethbridge, Alberta in 2016 to create a *Perception* campaign through IINNII, an artist-run centre there. They were impressed by the project's ability to address serious issues without alienating the viewer.

When I started this project, my intent was to combat racism and present First Nations, Métis, and Inuit people in the ways they see themselves. I expected some backlash, but instead got nothing but support. Strangers, both Indigenous and non-Indigenous, were telling me about their positive experiences after seeing the work. My mother's cribbage group explained how they talked about discrimination during their card games. An aspiring lawyer told me that he started a discussion with his close friends about invisible racism in hiring practices. An Indigenous woman thanked me for giving us a voice and platform. These are just a few examples of how this art has affected people's lives. My intent for this book is to give hope to the First Nations, Métis, and Inuit people for a better future and to remind people that discrimination must never be tolerated.

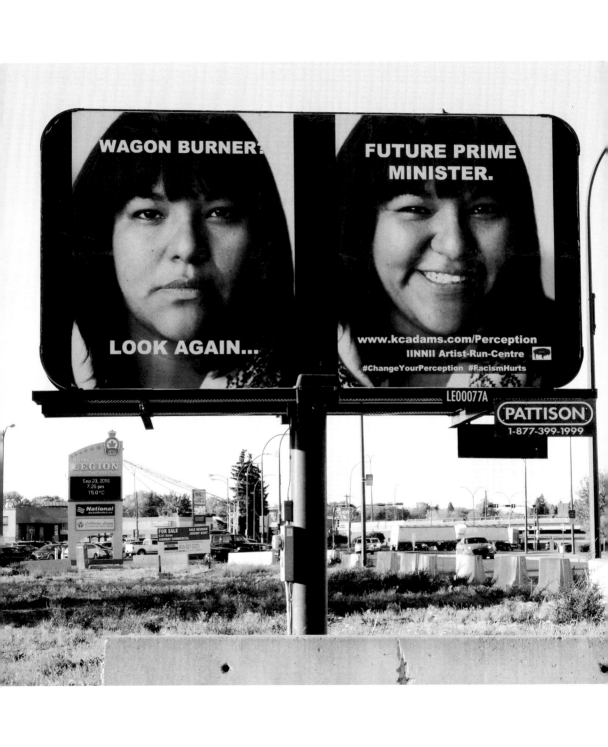

CATHY MATTES

The Perception Series:
KC Adams, and the Value
of Socially Engaged Art

Art is a catalyst for social change, and Winnipeg-based artist KC Adams (Oji-Cree) is a social-change agent. Her work addresses racism toward Indigenous peoples, engagement with the land and ceremony, the association between nature and technology, and the benefits of community and kin. With ceramics, photography, beadwork, collaborative performance, and installation, she holds up a mirror to society, and provides opportunities for viewers to participate, reflect, and strategize to make personal and collective change. Adam's photo-based series *Perception* challenges racist stereotypes and remedies the aftershocks of historical colonization and its continuous and present hold on contemporary Canadian society. The series relies on willing participants and an invested audience, and is best described as socially engaged art.

Although all art invites social interaction, socially engaged art depends on the involvement of others. Historically, it occurred in art galleries, where artists made artworks which were participatory and appealing, like convening visitors to share food or personal narratives in exhibition spaces. This blurred the lines between artist and audience, and broadened understandings of what constitutes art. Physical art objects or video recordings became the residuals or documentation of the process-based artwork instead of the main component.[1]

1. For example, in 1992, Rirkrit Tiravanija created *Untitled Free/Still* at 303 Gallery in New York, where he served visitors curry and rice and encouraged them to convene together and eat in the gallery space.

15

Socially engaged art now often happens *outside* of gallery spaces, and artists are driven to not only challenge understandings of art, but also to make social change. They address concerns like gender inequality, poverty, or the effects of colonial oppression. They collaborate with the public to paint murals on buildings, make posters for distribution, organize pop-up exhibitions in storefronts, and create performance works at community gatherings. They activate conversations that promote self-reflection or cross-cultural education and respond to the current issues of their time. For Indigenous artists, socially engaged art is more than a yearning to make right in society; it is also about their own relationships to the land, and a way to personally and collectively heal from the negative impact of colonization. It requires making art in a good way, grounded in culture, community, and kinship ties.

KC Adams began the *Perception* series after the Idle No More movement had greatly increased conversations between Indigenous and non-Indigenous people, with teach-ins, flash mobs, and a strong social-media presence. Around the same time, the body of 15-year-old murdered Tina Fontaine and that of 50-year-old Faron Hall, a homeless man known for saving two drowning people, were found in the Red River. These deaths, combined with a racist rant by a mayoral candidate's wife circulated on social media, were stark reminders of the disparaging impact injustice, faulty government systems, and racism has on Indigenous lives.

There were also inspiring socially engaged art projects initiated by other Indigenous artists that addressed the high number of Missing and Murdered Indigenous Women (MMIW) in Canada. *Walking With Our Sisters* (2012–18) was conceived by Christi Belcourt (Métis), and was a travelling commemorative art project that featured over 1800 pairs of moccasin vamps (also called

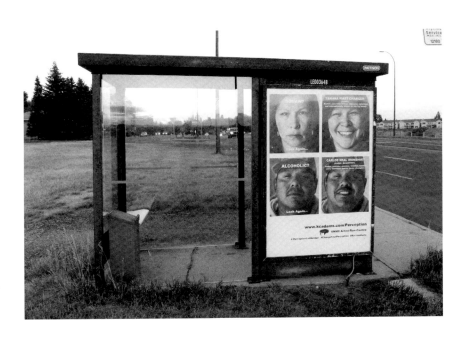

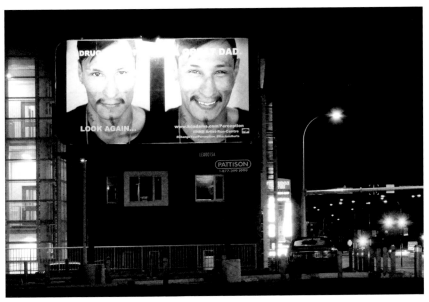

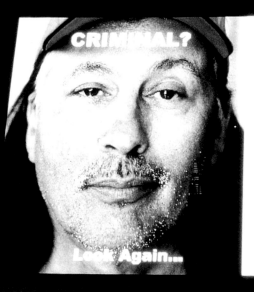

CRIMINAL?

Look Again...

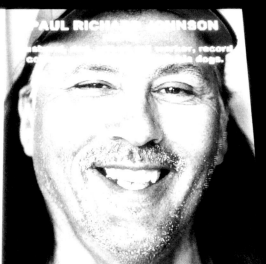

PAUL RICHARD JOHNSON

"uppers" or "tops") created and donated by hundreds of caring and concerned individuals to draw attention to the 1,181+ women and girls who have been murdered or gone missing across Canada since 1980. The adorned vamps are intentionally not sewn into moccasins, to represent those whose lives were cut short when they were taken from us. One hundred eight of the vamps were also created to honour the children whose lives were lost in the Canadian residential-school system.[2]

Métis artist Jaime Black launched the *REDress Project* in 2011. She put out a public call for the donation of red dresses, which she installed in public venues as quiet, solemn interventions. Collectively installed, the dresses are both reminders of the physical loss of MMIW, and vessels for the spirits of the women.

Both collaborative art projects were visual reminders and catalysts for gatherings and workshops that offered opportunities for individual and collective social change. They kept the plight of MMIW in the public realm with art and helped create a foundation for Adams to initiate *Perception.*

Adams became motivated to create art that would provide a forum for dialogue about racism and racial stereotypes. Although seemingly innocent and unharmful, stereotypes leave negative, long-lasting impressions. They become the defining image for that which they come to represent, for example, the stoic warrior, Indian Princess, street person, or gang member descriptor is prioritized over realistic portrayals or understandings of Indigenous people. This makes for toxic interactions between Indigenous and non-Indigenous people. They therefore need to be eradicated for true reconciliation between Indigenous and non-Indigenous people to occur. To attempt this, Adams ambitiously chose to involve

2. See www.walkingwith
oursisters.ca

3. See www.theredress
project.org

the public in multiple spaces outside art galleries, igniting the *Perception* series on social media, and presenting it on billboards, bus shelters, posters, in print media, and in large-scale projections, (see pages 14, 17, and 19).

Adams put a public request to other Indigenous people on Facebook to make art with her to address racism. People from all walks of life volunteered to be photographed, including students, youth workers, singers, philanthropists, award-winning journalists, and community leaders. The work consisted of two side-by-side black and white portraits with text placed over the images. The participants' reactions to Adams calling them slurs were captured for the first photograph, and then their response to her encouraging them to think about positive experiences in the second. At the top of the left portrait were the racist slogans that Adams called them while taking their photograph, like "lazy squaw," "government mooch," "useless halfbreed," and "drug dealer." At the bottom of the photo were the words "look again…", meant to entice viewers to reconsider their perceptions.

Placed on the right panel at the top were personal descriptions by the participants that were revealing, humanizing, and, at times, cheeky and humorous. Common themes included family and community roles, interests and hobbies, and spiritual practices. In addition, corrections to misconceptions were provided, as participants asserted themselves as taxpayers, homeowners, and despite common belief, also having had to pay for their education. The contrasting facial expressions presented side by side, plus the assertive text, offered an opportunity to remember that first glances and opinions are often wrong, limited, or misguided.

As an Indigenous woman, Adams creates socially engaged art that requires culturally grounded and thoughtful actions. She must recognize the impact that colonization has on interpersonal experiences and relationships, and must value Indigenous knowledge, ways of being, and value systems. While photographing participants, Adams ensured that they left the experience feeling unharmed and provided them an opportunity to be presented in a genuine light, on their own terms. As she was asking that they make themselves vulnerable, she did the same, and included herself in the series as a way to connect with participants. In return, she was provided with new understandings of her Indigenous community and an opportunity for her own self-realization and empowerment.

According to art scholar Grant Kester, socially engaged, dialogical artworks can "challenge dominant representations of a given community, and create a more complex understanding of, and empathy for, that community among a broader public".[4] The *Perception* series did just that. Adam's call to participate in the *Perception* series was a request to help diminish the power of racist stereotypes and find common ground for all. The work instigated dialogue and debate, introspection, and resolution. It created solidarity for Indigenous audiences and participants, as it is familiar and relatable: the slurs have caused harm for many, the faces and expressions of participants resemble loved ones, and the personal descriptions instill pride for one another. Working in a collaboratively, culturally grounded way, Adams reminds us that it is important that we all "look again" before making up our minds.

4. Grant H. Kester, *Conversation Pieces – Community and Communication in Modern Art*, (California: University of California Press, 2004). Print,10.

Cathy Mattes is a Michif curator, writer, and art history professor at Brandon University, who is based in Sprucewoods, Manitoba.

PERCEPTION: A PHOTO SERIES

WELFARE MOM?

Look Again...

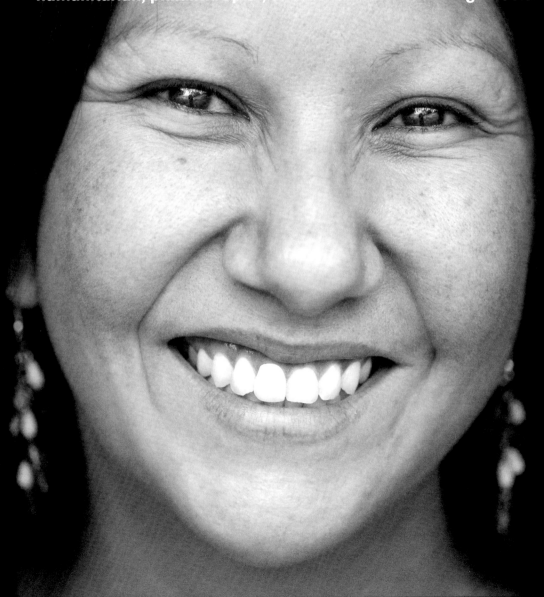

ALTHEA GUIBOCHE
(CREE/OJIBWAY)

Mother, daughter, Bannock Lady, poet, writer, activist, humanitarian, philanthropist, and bakes bannock in high heels.

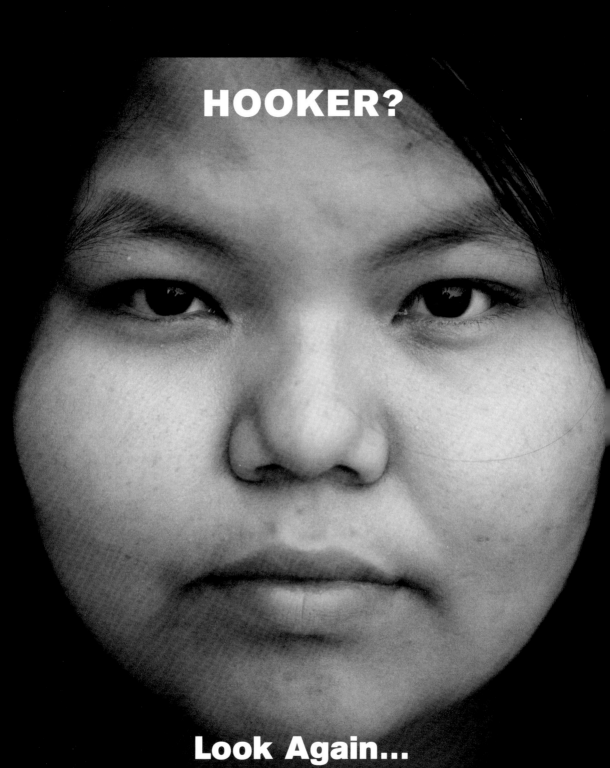

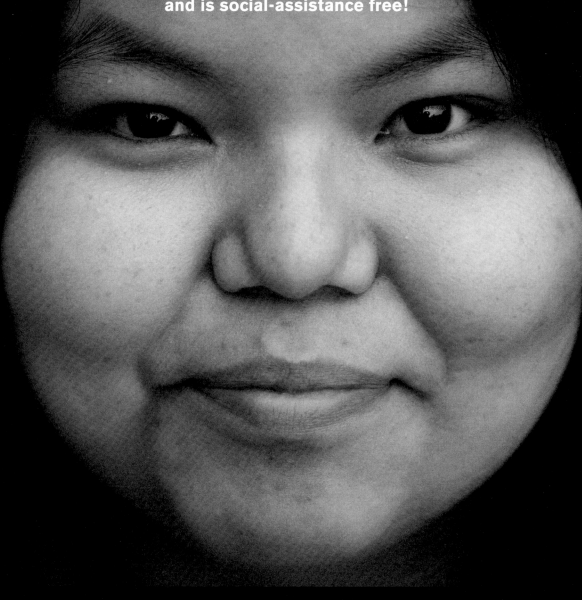

APRIL SINCLAIR
(OJIBWAY)

A mother, daughter, girlfriend, sister, high-school graduate, working mom, loves apples and coffee, and is social-assistance free!

TAX BURDEN?

Look Again...

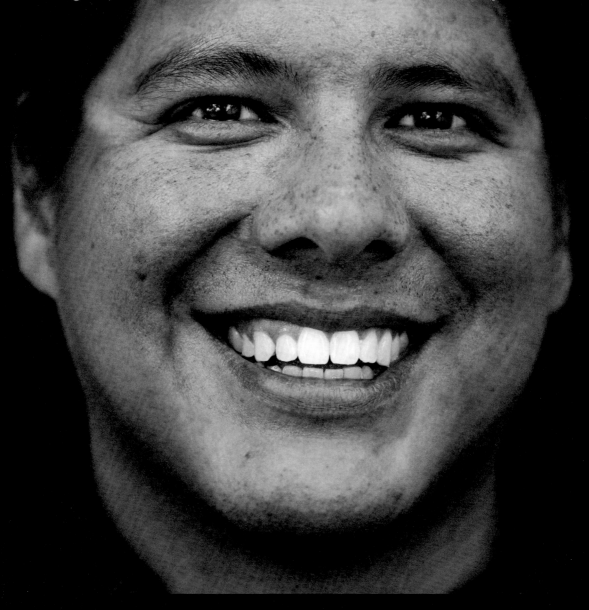

BRENNAN MANOAKEESICK

(OJI-CREE)

A husband, father, Sun Dancer, defender of treaty
rights, homeowner, and a Golden Jubilee medal recipient.

TRESPASSER?

Look Again...

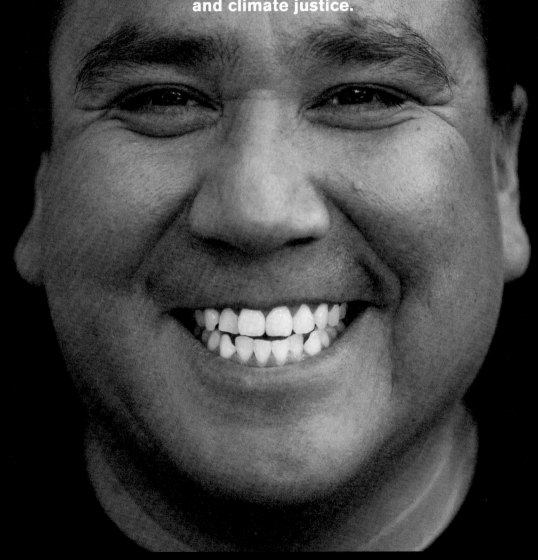

CLAYTON THOMAS MÜLLER ETHINEWAK

（CREE）

Husband, father, Sun Dance singer, pipe carrier, author, internationally acclaimed campaigner on Indigenous rights and climate justice.

YOUTH AT RISK?

Look Again...

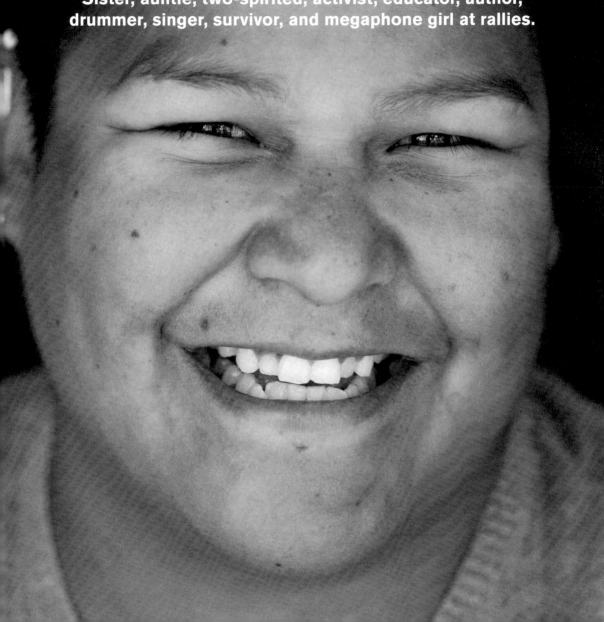

JENNA
(ANISHINAABE)

Sister, auntie, two-spirited, activist, educator, author, drummer, singer, survivor, and megaphone girl at rallies.

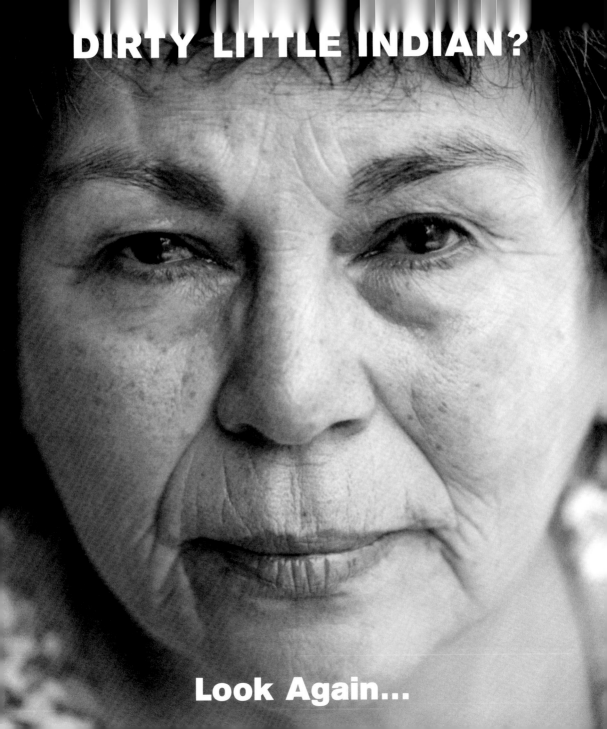

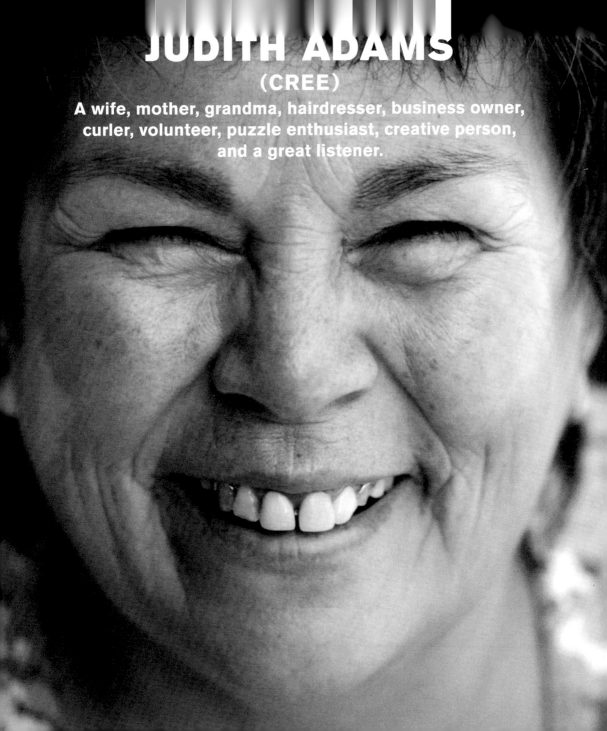

JUDITH ADAMS
(CREE)

A wife, mother, grandma, hairdresser, business owner, curler, volunteer, puzzle enthusiast, creative person, and a great listener.

USELESS HALFBREED?

Look Again...

KATHERENA VERMETTE
(MÉTIS)

A mom, writer, fiancée, educator, arts coordinator, volunteer, yogi, homeowner, little-dog owner, Governor General Literary Award Winner, and still paying for grad school herself.

HOMELESS?

Look Again...

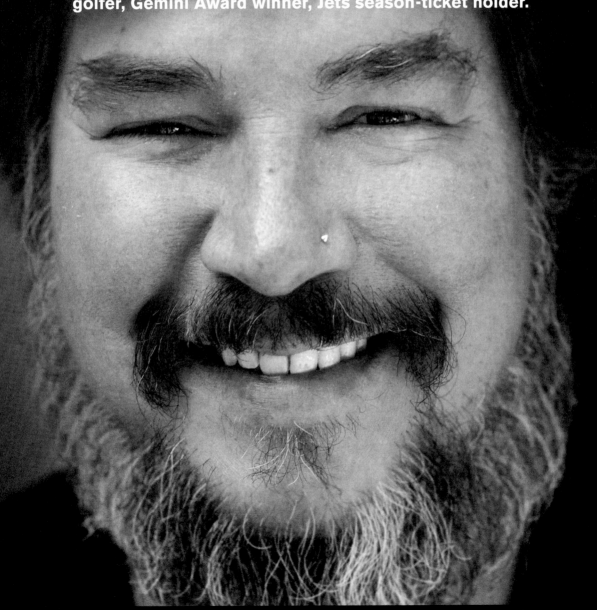

JORDAN WHEELER
(CREE)

A husband, father, stepfather, brother, uncle, writer, golfer, Gemini Award winner, Jets season-ticket holder.

SQUAW?

Look Again...

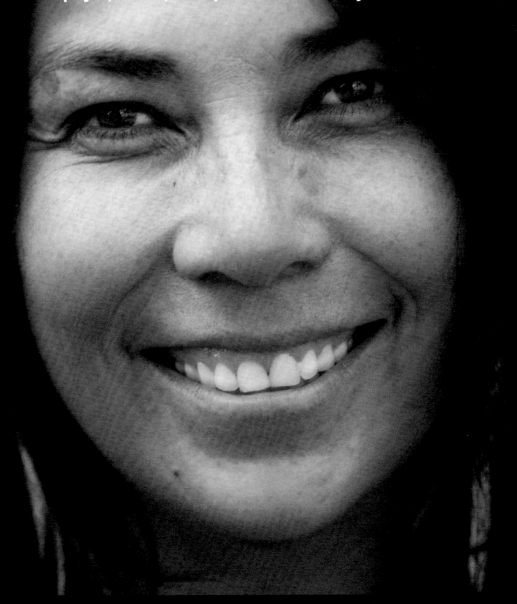

KC ADAMS
(OJI-CREE)

A wife, mother, twin, artist, educator, homeowner, taxpayer, curler, who paid for university herself.

NONVOTER?

Look Again...

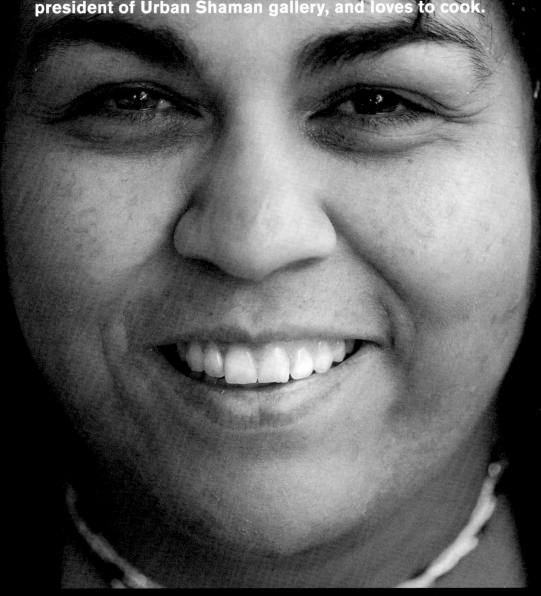

KELLI ADAMS-WITYK
(OJI-CREE)
A wife, mother, university graduate, government worker, campaign manager with the All Charities Campaign, president of Urban Shaman gallery, and loves to cook.

GOVERNMENT MOOCH?

Look Again...

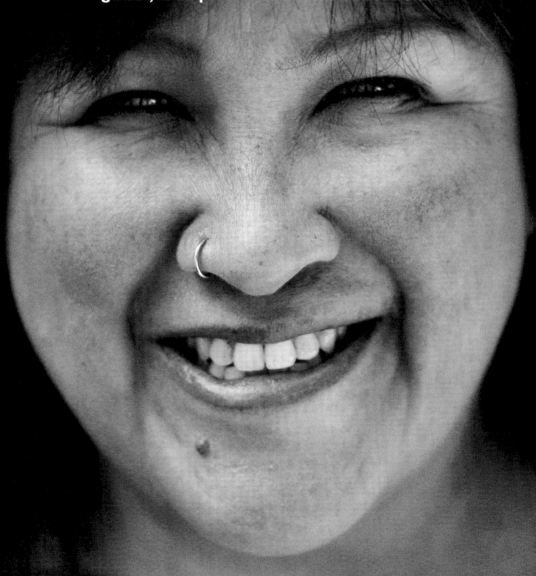

KIM WHEELER
(OJIBWAY/MOHAWK)

A mother, writer, publicist, producer, homeowner, golfer, who paid for her own education.

FOSTER KID?

Look Again...

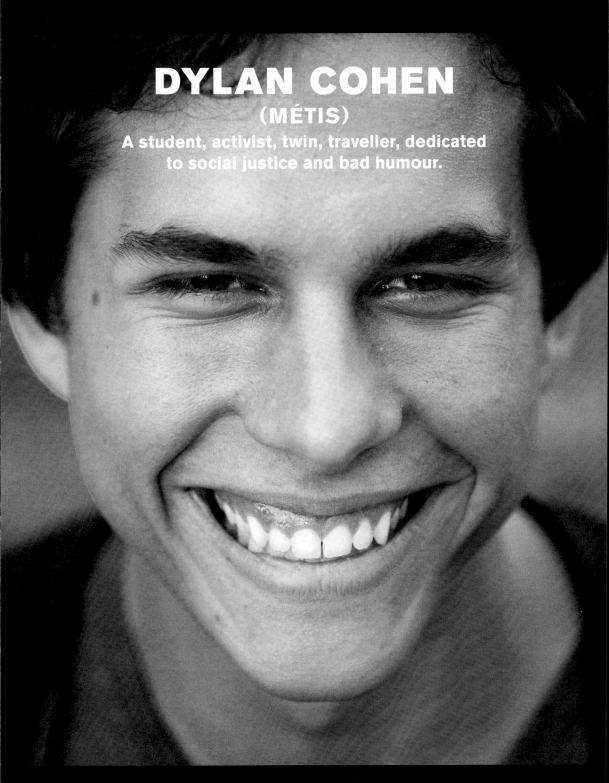

DYLAN COHEN
(MÉTIS)
A student, activist, twin, traveller, dedicated
to social justice and bad humour.

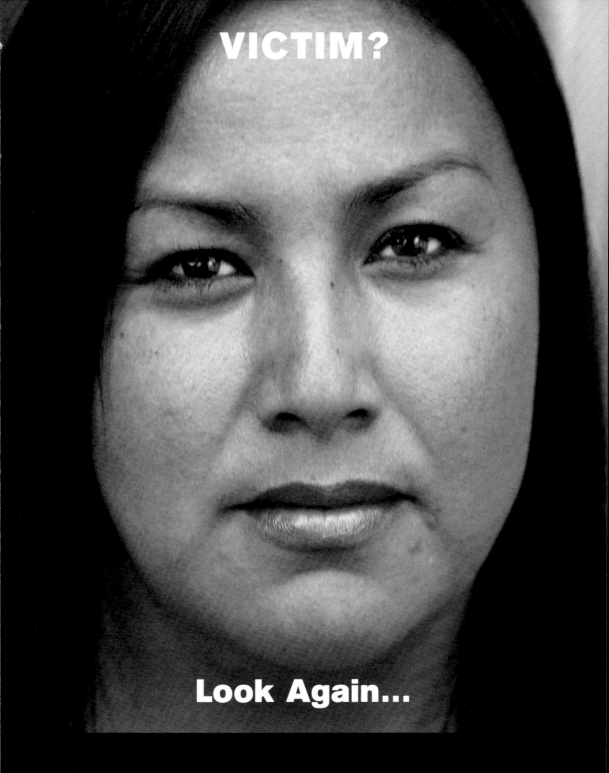

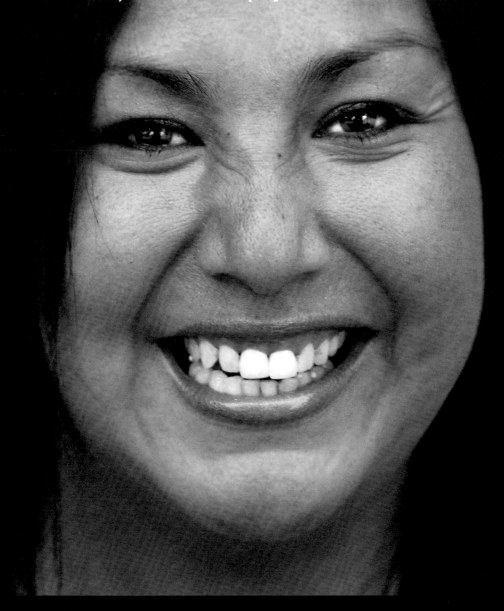

LEONA STAR

(CREE)

A wife, mother, sister, Sun Dancer, researcher, taxpayer,
homeowner, and a softball player with a wicked arm.

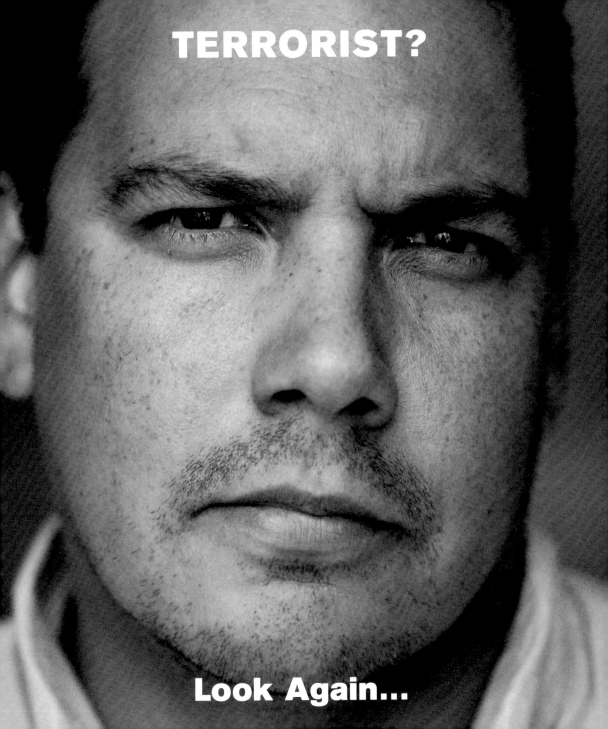

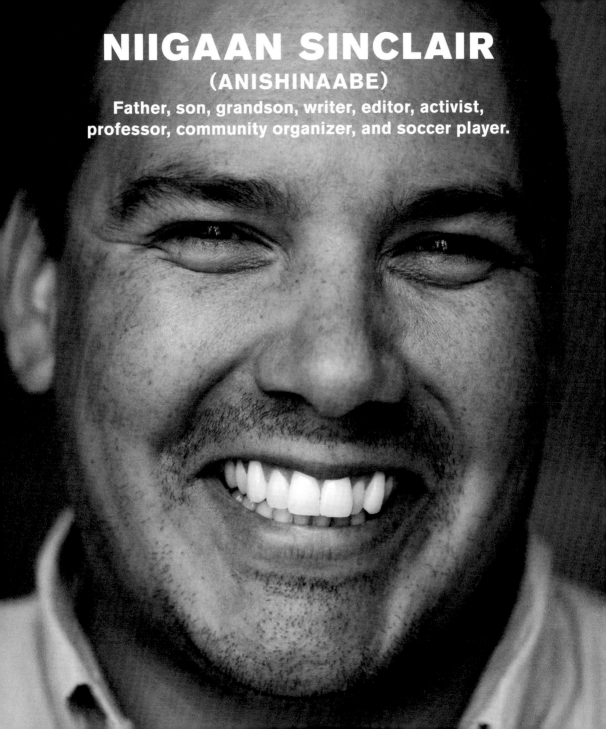

NIIGAAN SINCLAIR
(ANISHINAABE)

Father, son, grandson, writer, editor, activist, professor, community organizer, and soccer player.

FETAL ALCOHOL SYNDROME?

Look Again...

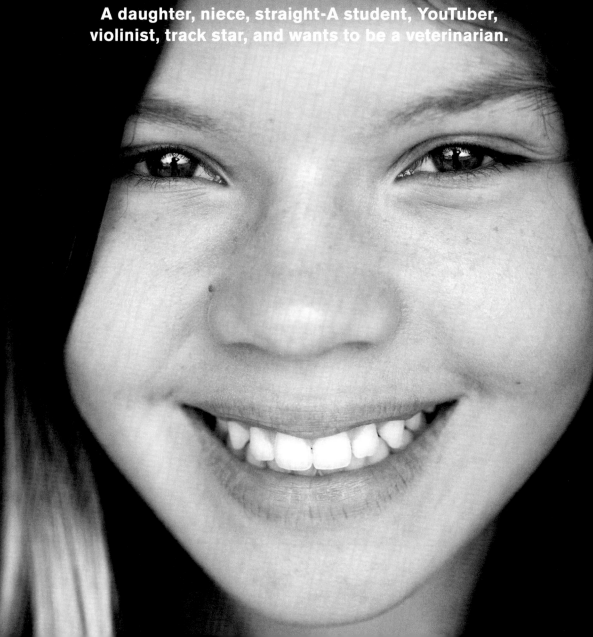

NUNGOHS
(OJIBWAY/POTAWATOMI)
A daughter, niece, straight-A student, YouTuber, violinist, track star, and wants to be a veterinarian.

STUPID INDIAN?

Look Again...

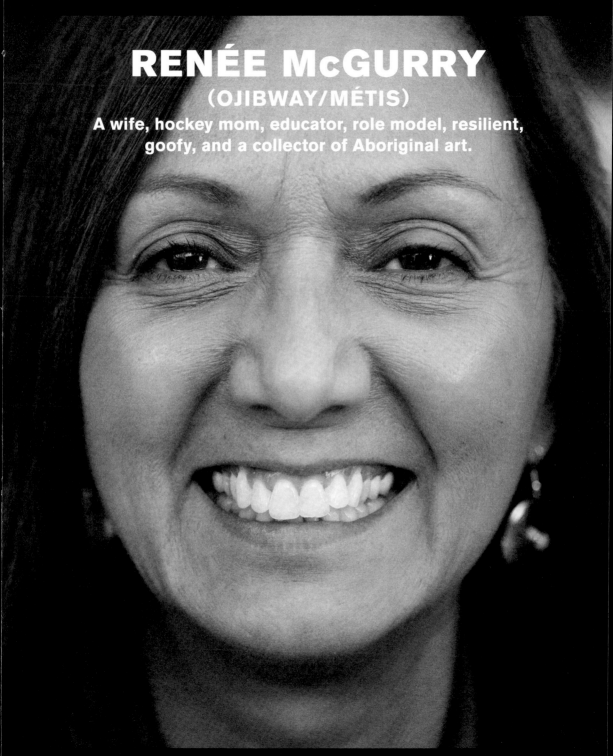

RENÉE McGURRY
(OJIBWAY/MÉTIS)
A wife, hockey mom, educator, role model, resilient, goofy, and a collector of Aboriginal art.

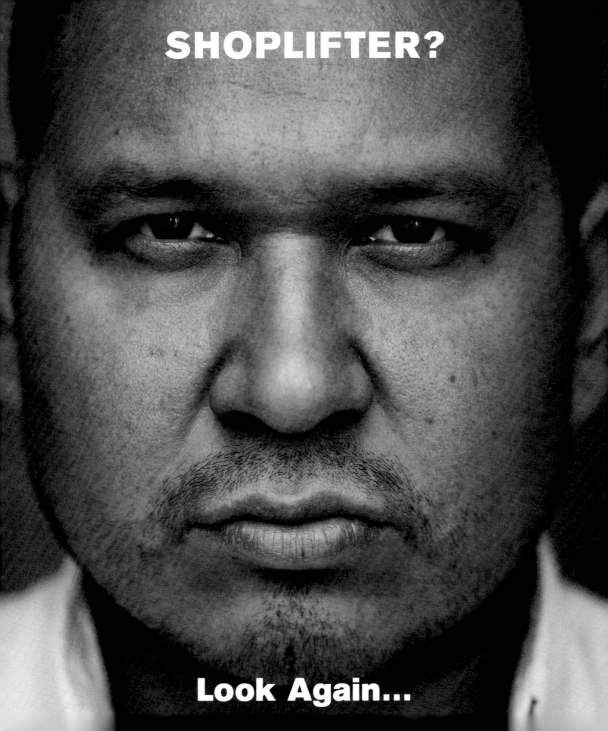

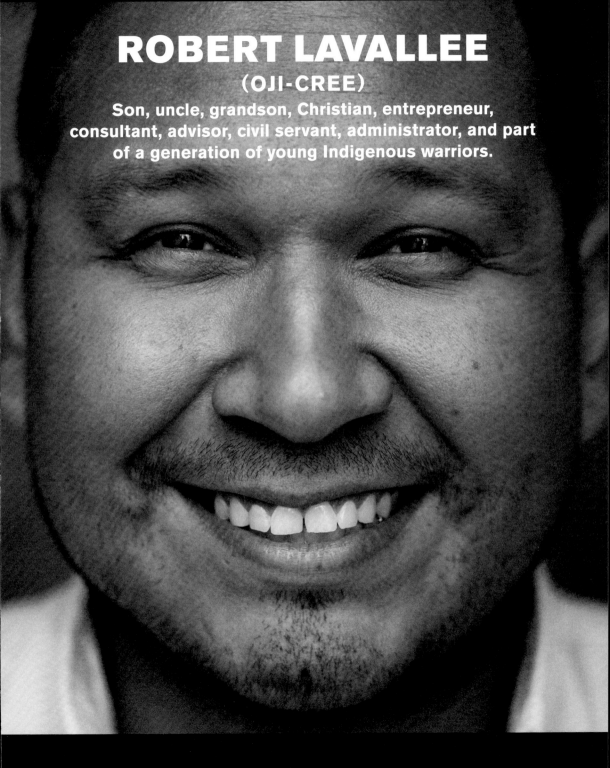

ROBERT LAVALLEE
(OJI-CREE)
Son, uncle, grandson, Christian, entrepreneur, consultant, advisor, civil servant, administrator, and part of a generation of young Indigenous warriors.

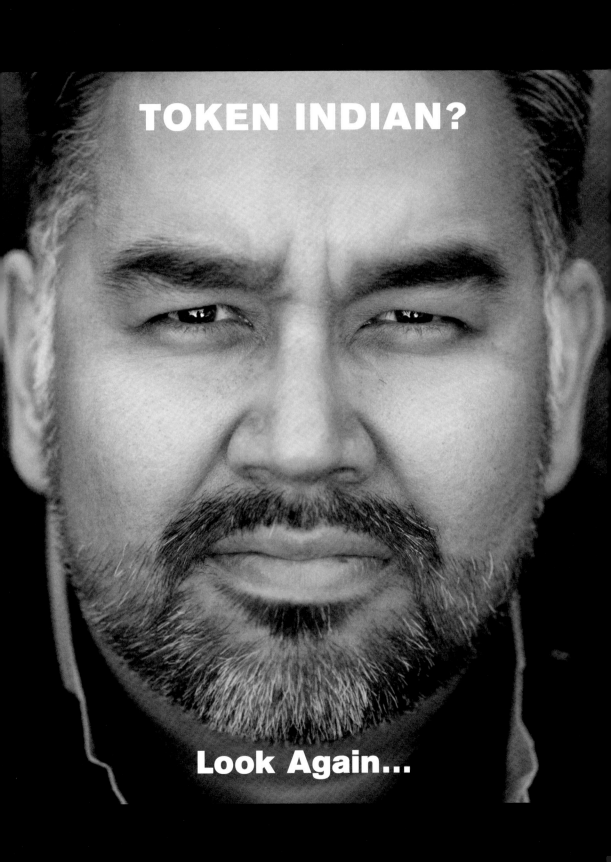

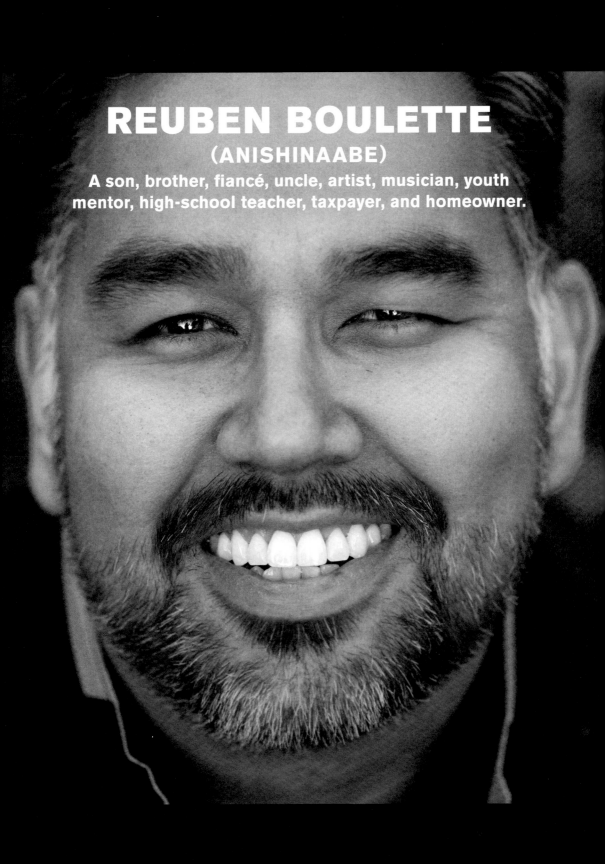

REUBEN BOULETTE
(ANISHINAABE)

A son, brother, fiancé, uncle, artist, musician, youth mentor, high-school teacher, taxpayer, and homeowner.

WHORE?

Look Again...

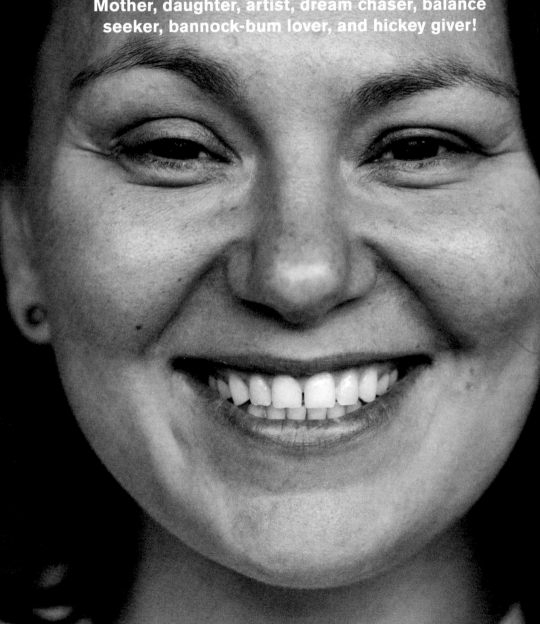

TANYA TAGAQ

(INUIT)

Mother, daughter, artist, dream chaser, balance
seeker, bannock-bum lover, and hickey giver!

DRUG ADDICT?

Look Again...

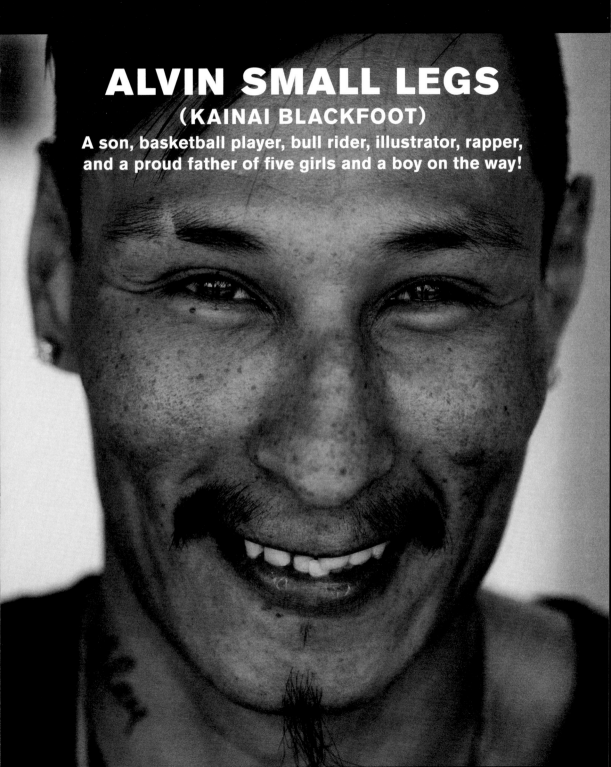

ALVIN SMALL LEGS
(KAINAI BLACKFOOT)
A son, basketball player, bull rider, illustrator, rapper, and a proud father of five girls and a boy on the way!

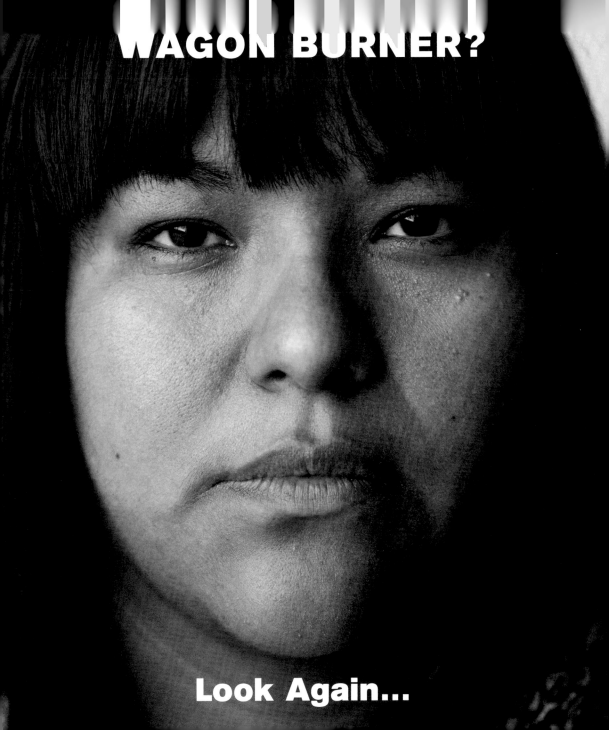

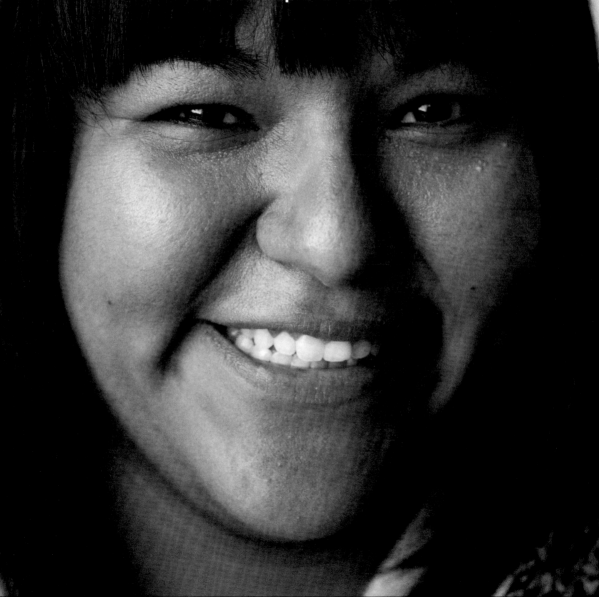

ABBY MORNING BULL

(BLACKFOOT/NEZ PERCE/CREE)

Daughter, aunt, sister, friend, taxpayer, fan of anime
and future prime minister.

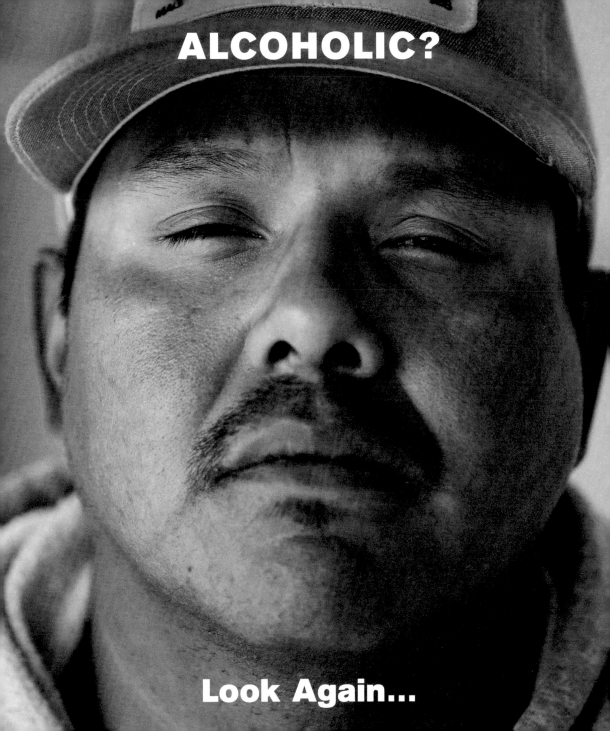

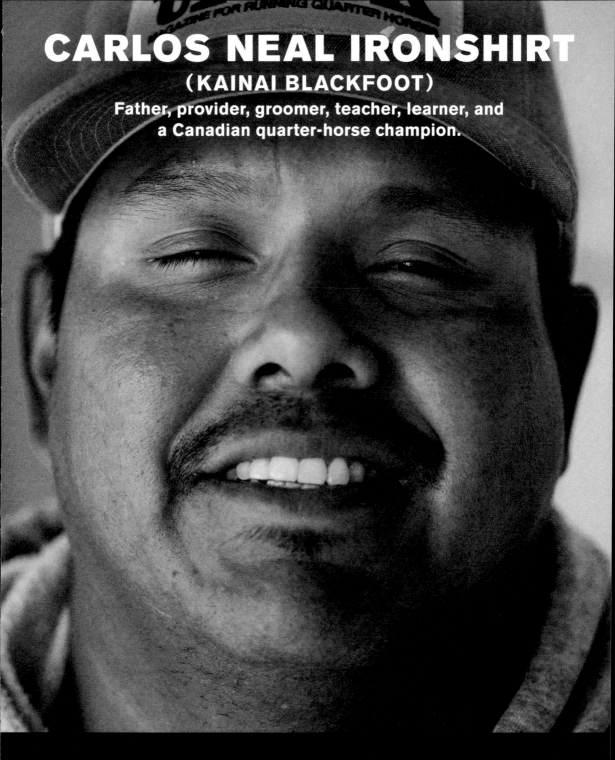

CARLOS NEAL IRONSHIRT

(KAINAI BLACKFOOT)

Father, provider, groomer, teacher, learner, and
a Canadian quarter-horse champion.

WELFARE RECIPIENT?

Look Again...

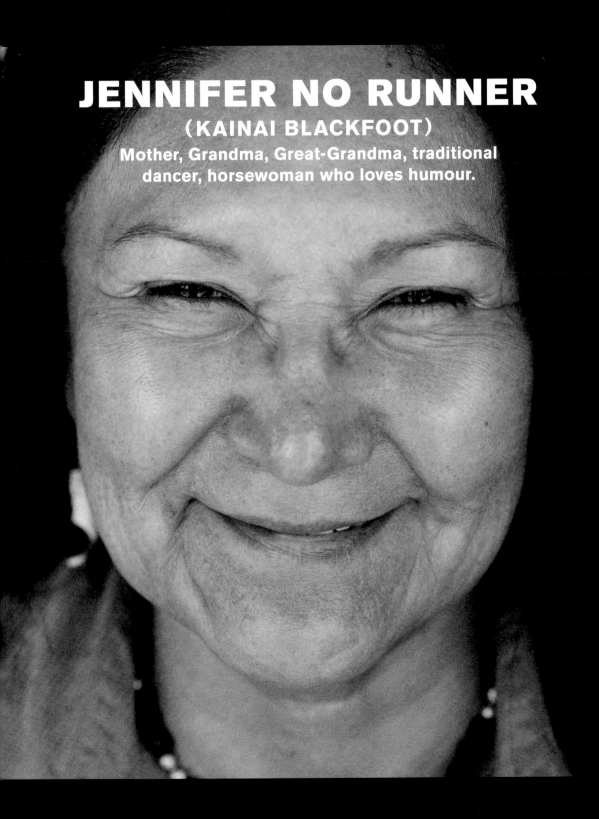

JENNIFER NO RUNNER
(KAINAI BLACKFOOT)
Mother, Grandma, Great-Grandma, traditional
dancer, horsewoman who loves humour.

DRUNKEN INDIAN?

Look Again...

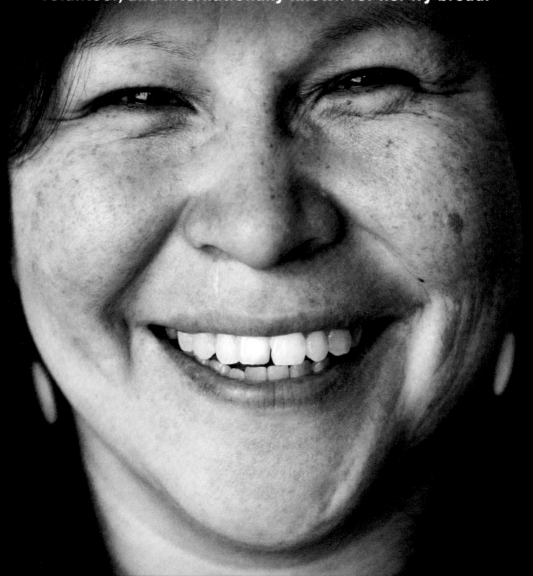

TAMARA FIRST CHARGER
(KAINAI BLACKFOOT)
Mother, sister, auntie, daughter, strong, fierce, independent woman, pow-wow dancer, educator, volunteer, and internationally known for her fry bread.